DTS

A Pictorial Essay on Pointed, Printed Patterns

Tina Skinner

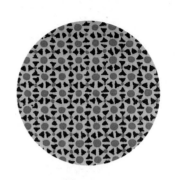

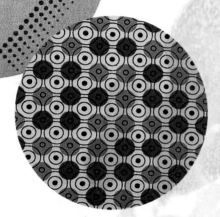

Schiffer Publishing Ltd ®

4880 Lower Valley Road, Atglen, PA 19310 USA

Designed by Bonnie M. Hensley
Typeset in Geometric 231 Hv BD/Korrina

ISBN: 0-7643-0634-0
Printed in China

Published by Schiffer Publishing Ltd.
4880 Lower Valley Road
Atglen, PA 19310
Phone: (610) 593-1777; Fax: (610) 593-2002
E-mail: Schifferbk@aol.com
Please write for a free catalog.
This book may be purchased from the publisher.
Please include $3.95 for shipping.

In Europe Schiffer books are distributed by
Bushwood Books
6 Marksbury Avenue
Kew Gardens
Surrey TW9 4JF England
Phone: 44 (0) 181 392-8585; Fax: 44 (0) 181 392-9876
E-mail: Bushwd@aol.com

Please try your bookstore first.

We are interested in hearing from authors
with book ideas on related subjects.

Contents

Introduction

Imagine a time way back, before art had even been imagined yet. It's easy to believe that a dot was the first work of art, the result of an accidental meeting of a piece of charcoal or graphite with a hard, white slab of stone. This first dot occasioned some surprise, and subsequent experimentation, leading to the invention of polka dots, stripes, and eventually to antelope and dodo bird depictions.

Dots are one of the most useful tools available to today's more sophisticated designers, providing background for any number of motifs, or standing alone in a pointed fashion statement. Dots' contribution to fashion history is no itsy bitsy, teeny weenie tale, and this book attempts to chronicle the diverse applications of the form over the course of half a century. In all, 540 fabric swatches from couture fabric design houses in the United States, France, and Italy have been photographed and displayed here, to educate and inspire aspiring artists and designers. Most importantly, though, it's time dots got their due. Dot's all.

Just Dots

White on magenta. Silk twill, United States, 1940s.

White on olive. Silk twill, United States, 1940s.

White on blue. Cotton, United States, 1966.

White on red. Cotton, United States, 1966.

Black on white. Silk, United States, 1940s.

Black on red. Silk, United States, 1940s.

White on taupe. Cotton, United States, 1966.

White on pink. Cotton, United States, 1966.

White on navy. Cotton, United States, 1938.

White on blue. Cotton, United States, 1966.

White on red. Cotton, United States, 1968.

White on black. Cotton, United States, 1966.

White on chocolate brown. Silk, United States, 1940s.

White on navy blue. Silk, United States, 1940s.

White on blue. Silk, United States, 1940s.

White on green. Silk, United States, 1940s.

White on maroon. Silk, United States, 1940s.

White on chocolate brown. Silk, United States, 1940s.

White on orange. Silk, United States, 1940s.

White on navy. Silk, United States, 1940s.

White on dark pink. Silk, United States, 1940s.

White on gray. Silk, United States, 1940s.

Blue on salmon. Silk, United States, 1940s.

Two tones of blue. Silk, United States, 1940s.

White on red. Silk, United States, 1940s.

Yellow on green. Silk, United States, 1940s.

Navy blue on yellow. Silk, United States, 1940s.

Yellow on black. Silk, United States, 1940s.

Pink on black. Silk, United States, 1940s.

Pink on navy blue. Silk, United States, 1940s.

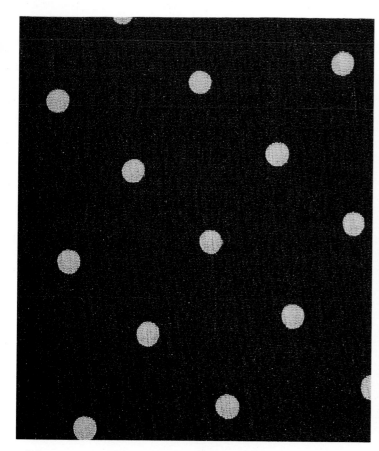

White on navy. Silk crepe, United States, 1940s.

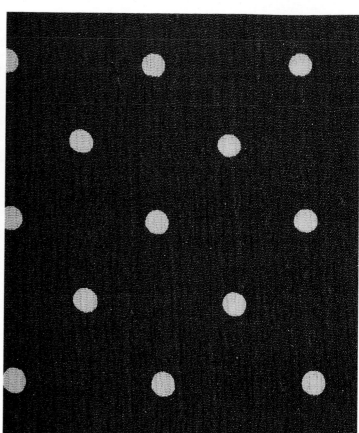

White on chocolate brown. Silk crepe, United States, 1940s.

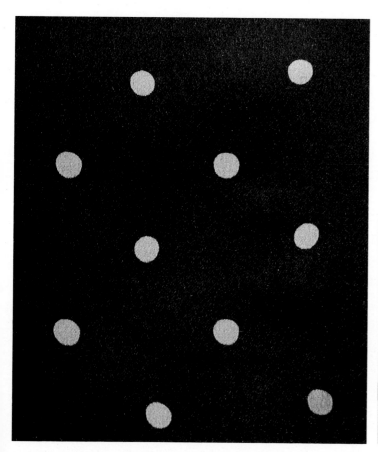

Light blue on navy. Silk satin, United States, 1940s.

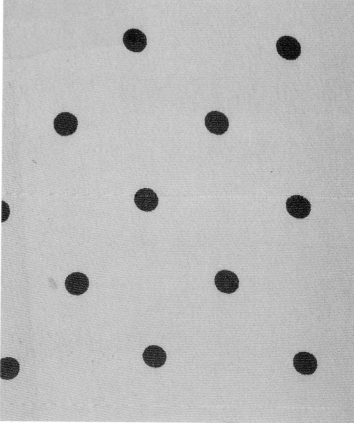

Chocolate brown on yellow. Silk, United States, 1940s.

Green on blue. Silk, United States, 1940s.

Magenta on purple. Silk, United States, 1940s.

White on beige. Silk, United States, 1940s.

White on pink. Silk twill, United States, 1940s.

White on midnight blue. Silk, United States, 1940s.

White on rust. Silk, United States, 1940s.

Light blue on blue. Silk, United States, 1940s.

Dark on light brown. Silk, United States, 1940s.

White on pink. Silk crepe, United States, 1940s.

Brown on yellow. Silk, United States, 1940s.

White on green. Silk, United States, 1940s.

Pink on purple. Silk, United States, 1940s.

Turquoise on black. Silk, United States, 1940s.

Green on purple. United States, 1940s.

Lavender on black. Silk, United States, 1940s.

Red on black. Silk, United States, 1940s.

Green on white. Silk crepe, United States, 1940s.

White on pink. Silk crepe, United States, 1940s.

Beige on navy. Silk crepe, United States, 1940s.

Brown on white. Silk crepe, United States, 1940s.

Blue on white. Silk crepe, United States, 1940s.

Green on white. Silk, United States, 1940s.

Orange on green. Silk, United States, 1940s.

White on blue. Silk crepe, United States, 1940s.

Green on navy. Silk, United States, 1940s.

Gold on navy. Silk, United States, 1940s.

Brown on yellow. Slubbed silk, United States, 1940s.

Dark blue on white. Cotton novelty weave, France, 1964.

Purple on black. Silk, United States, 1940s.

White on dark pink. Silk, United States, 1940s.

Pink with white outline on purple. Silk, United States, 1940s.

Blue on blue, slubbed silk, United States, 1940s.

Olive green on yellow. Silk crepe, United States, 1940s.

White on gray. Silk, United States, 1940s.

Dark pink on purple. Silk, United States, 1940s.

White on maroon. Silk, United States, 1940s.

Red on white ground. Cotton, United States, 1959.

Brown on white ground. Cotton, United States, 1959.

Blue on white ground. Cotton, United States, 1959.

Pink on white ground. Cotton, United States, 1959.

Green on white. Cotton, United States, 1959.

Black on white ground. Cotton, United States, 1959.

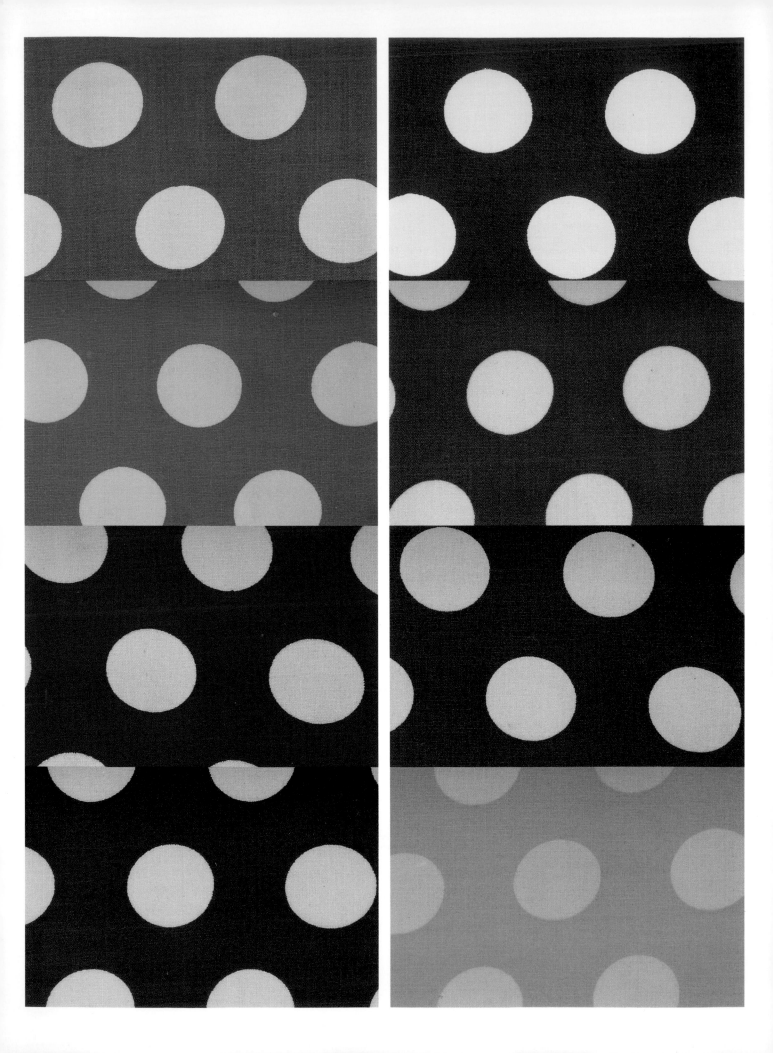

Purple on pink. Silk, United States, 1940s.

Pink on purple. Silk, United States, 1940s.

Pale blue on brown. Slubbed silk, United States, 1940s.

White on black. Slubbed silk, United States, 1940s.

Red on white. Silk twill, United States, 1940s.

Pink on white. Silk twill, United States, 1940s.

Light blue on navy. Silk twill, United States, 1940s.

White on maroon. Silk, United States, 1940s.

Light on dark brown. Silk, United States, 1940s.

White on maroon. Silk, United States, 1940s.

Light on dark green. Silk, United States, 1940s.

White on black. Silk, United States, 1940s.

Yellow on black. Silk, United States, 1940s.

Salmon on black. Silk, United States, 1940s.

Black on salmon. Silk, United States, 1940s.

Black on yellow. Silk, United States, 1940s.

White on red. Silk, United States, 1940s.

White on navy. Silk, United States, 1940s.

White on orange. Silk, United States, 1940s.

White on blue. Silk, United States, 1940s.

Black on dark pink. Silk, United States, 1940s.

White dots on blue ground. Cotton, United States, 1948.

White dots on red ground. Cotton, United States, 1948.

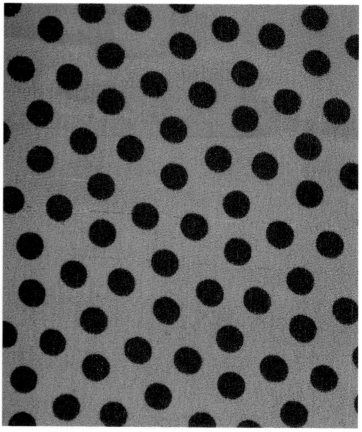

Black on green. Silk, United States, 1940s.

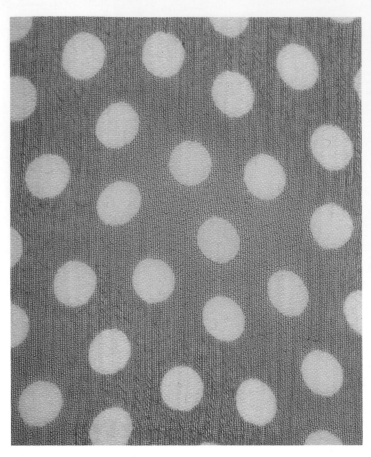

White on green. Silk, United States, 1940s.

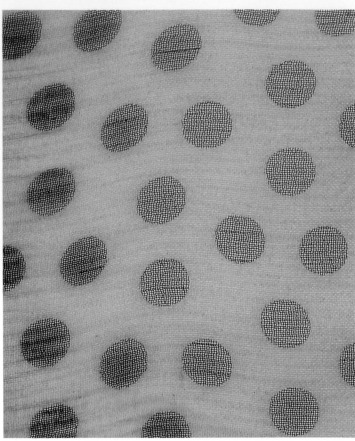

Charcoal on pink. Silk crepe, United States, 1940s.

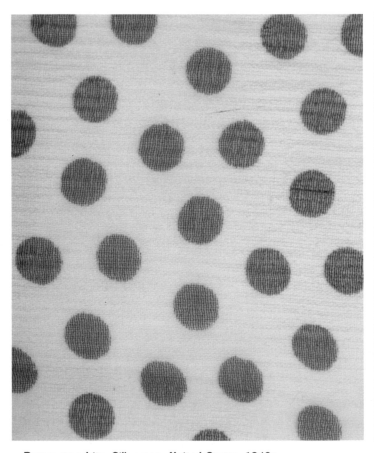

Brown on white. Silk crepe, United States, 1940s.

Blue on white. Silk crepe, United States, 1940s.

Red on black. Silk, United States, 1940s.

White on navy blue. Silk, United States, 1940s.

White on brown. Silk, United States, 1940s.

White on red. Silk, United States, 1940s.

White on green. Silk, United States, 1940s.

White on red. Silk, United States, 1940s.

White on black. Silk, United States, 1940s.

White on red. Silk, United States, 1940s.

Black on gold. Silk, United States, 1940s.

Black on green. Silk, United States, 1940s.

Black on salmon. Silk, United States, 1940s.

Black on blue. Silk, United States, 1940s.

Tan on black ground. Silk, United States, 1930s.

Orange and blue on white. Silk twill, France, 1967.

Pink and black on white. Cotton, United States, 1950.

Clustered black dots on white ground. Rayon twill, France, 1964.

Red, green and black dots on white ground. Cotton, United States, 1954.

Yellow, green, and black on white ground. Cotton, United States, 1954.

Brown, bright green, and dark pink dots on white ground. Cotton, United States, 1954.

Lavender, turquoise, and yellow dots on white ground. Cotton, United States, 1954.

Chapter Two

Dots in a Row

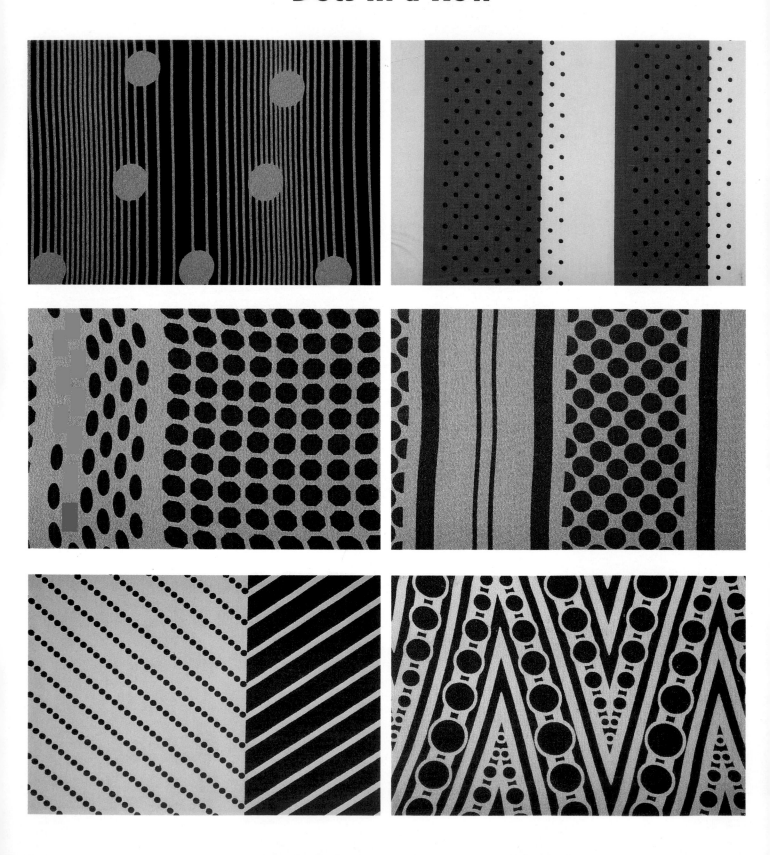

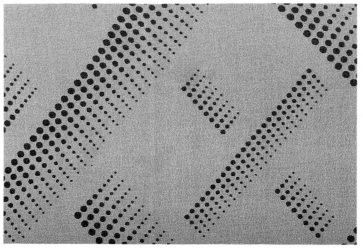

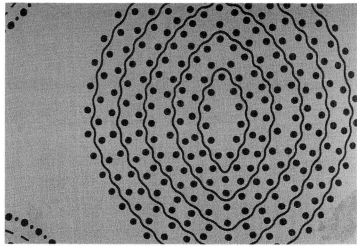

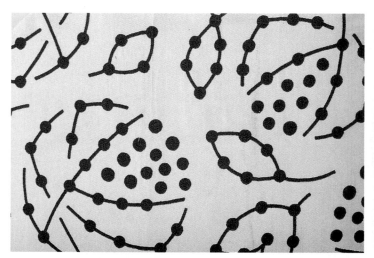

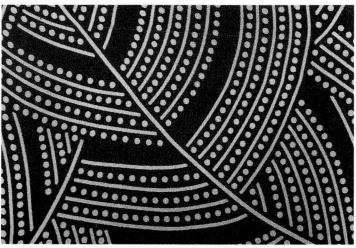

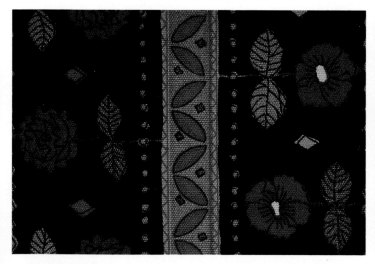

Opposite page:
Top left: Dots on varied width stripes. Polyester blend, United States, 1930s.
Top right: Black dots on white and red vertically striped ground. Cotton, United States, 1958.
Center left: A vertical striped pattern of squared and elongated dots. Silk, United States, 1930s.
Center right: Wide dotted stripes in vertical pattern. Silk, United States, 1930s.
Bottom left: Diagonal solid and dotted white and blue stripes form chevron pattern. United States, 1940s.
Bottom right: Outlined circles on zigzag stripes. Silk, United States, 1930s.

Top left: Dots form oversized grid. Silk, United States, 1930s.
Top right: Dots adorn scalloped ovals. Silk, United States, 1930s.
Center left: Black on white. Silk, United States, 1930s.
Center right: A dot and stripe design. Silk, United States, 1930s.
Bottom left: Dotted lines in floral vertical stripe pattern. Cotton. France, 1963.
Bottom right: Orange on brown stripes. Cotton/polyester. France, 1963.



Grid-locked Dots

Top left: Blue dots form plaid pattern on beige ground. Polyester blend, United States, 1930s.

Center left: Blues on blue. Cotton rayon twill. France, 1963.

Bottom left: Dots form random squares. Silk, United States, 1930s.

Top right: Dots provide center for navy and bone grid. Silk, United States, 1930s.

Center right: Dots form grid in red, white, and blue plaid. Cotton, United States, 1953.

Bottom right: Vertical stripe pattern. Silk, United States, 1930s.

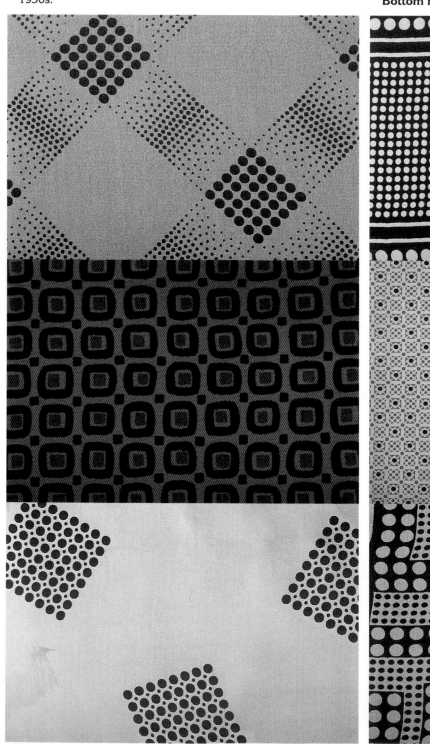
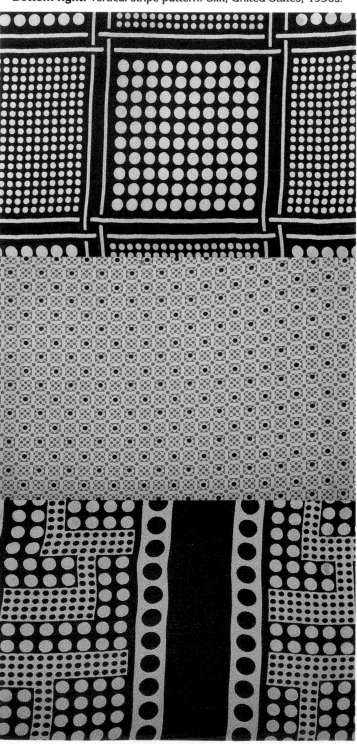

Dotted checks provide contrast in plaid. Silk, United States, 1930s.

Dots adorn curved windowpane grid and floral design. Silk, United States, 1930s.

Dots form grid and provide decoration in red, yellow, and turquoise plaid. Cotton, United States, 1953.

Circles and dots create a calico grid. Cotton, United States, 1958.

Dots and snowflakes on blue. Cotton, United States, 1938.

Black dots in red and white harlequin design. Cotton, United States, 1938.

Dotted squares on black and red grid. Rayon, France, 1964.

Dots on pink and green harlequin pattern. Cotton, United States, 1938.

Outlined dots, black on pinks. Cotton rayon, France, 1964.

Pink, green, and black on beige. Viscose and silk, France, 1966.

Red, brown, and black on white. Rayon twill, France, 1963.

Red and navy blue stripes with yellow dotted harlequin design. Silk, United States, 1930s.

Magenta, sand, and blue dots behind large windowpane check. Cotton blend, France, 1962.

White dots create imitation weave. Rayon, France, 1964.

Dots are connected for harlequin grid. Wool blend, France, 1965.

Negative and positive design in blue and beige. Silk, United States, 1930s.

Dotted brown grid on white. Quilted cotton, France, 1965.

Brown dots in black grid on pink. Cotton, France, 1965.

Chapter Four

Dotted Background

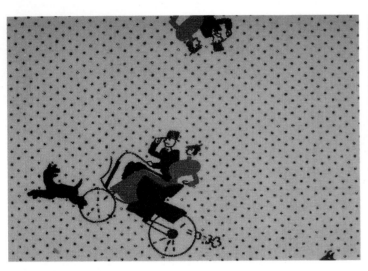

Bicyclists on dotted white ground. Browns. Cotton, United States, 1956.

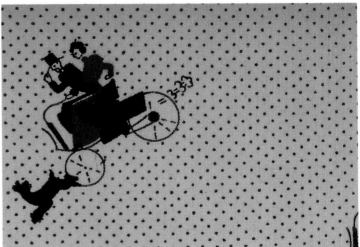

Bicyclists on dotted white ground. Red and black. Cotton, United States, 1956.

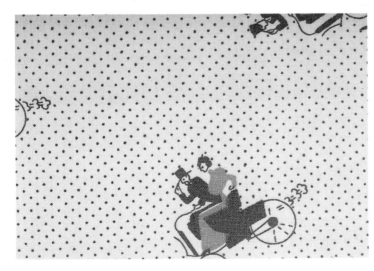

Bicyclists on dotted white ground. Blue and gray. Cotton, United States, 1956.

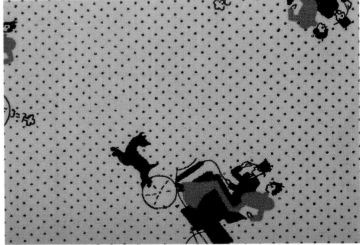

Bicyclists on dotted white ground. Lavender and black. Cotton, United States, 1956.

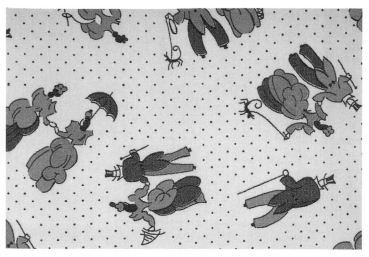

Gentrified couple walks on dotted ground. Cotton, United States, 1948.

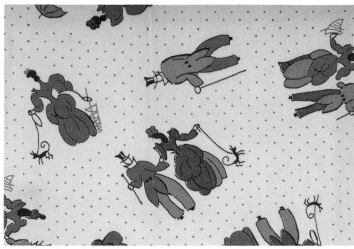

Gentrified couple walks on dotted ground. Cotton, United States, 1948.

Blue dots on white ground with blue fruit. Cotton, United States, 1970.

Red dots on white ground with red fruit. Cotton, United States, 1970.

Brown dots on white ground with yellow fruit. Cotton, United States, 1970.

Strawberries on red polka dot ground. Cotton, United States, 1958.

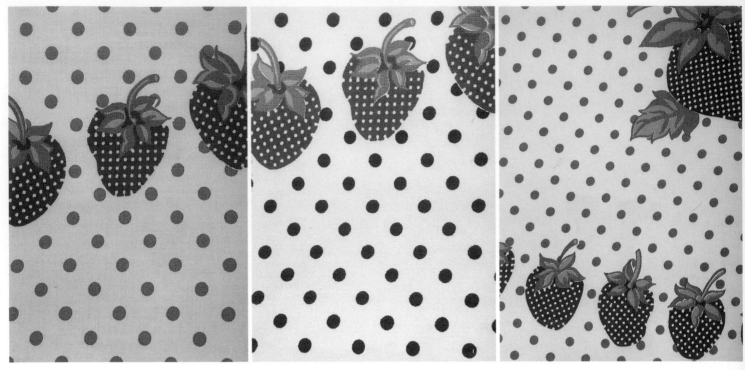

Dotted strawberries with green dots on white ground. Cotton, United States, 1950.

Dotted strawberries with dark blue dots on white ground. Cotton, United States, 1950.

Dotted strawberries with blue dots on white ground. Cotton, United States, 1950.

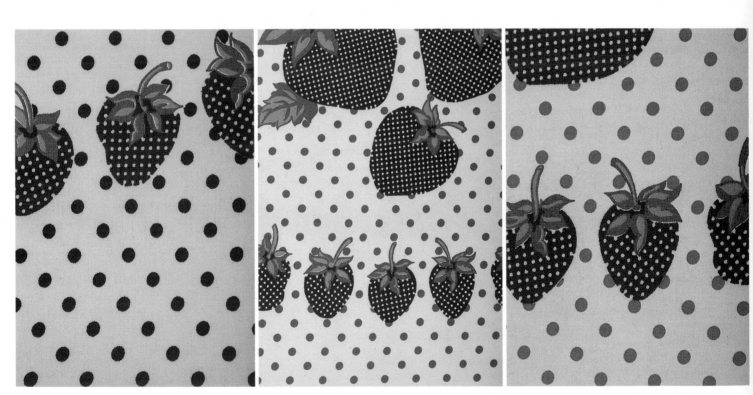

Dotted strawberries with red dots on white ground. Cotton, United States, 1950.

Dotted strawberries with blue dots on white ground. Cotton, United States, 1949.

Dotted strawberries with green dots on white ground. Cotton, United States, 1949.

Dotted grid for country theme. Pink and greens. Cotton, United States, 1966.

Dotted grid for country theme. Blues and green. Cotton, United States, 1966.

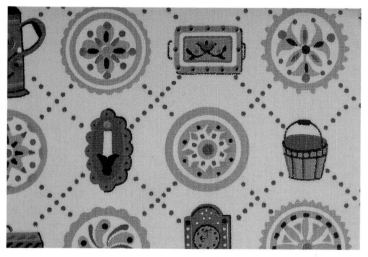

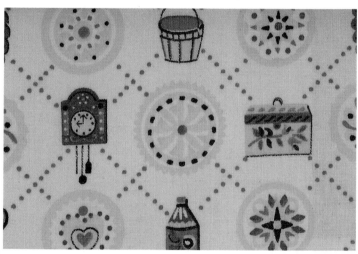

Dotted grid for country theme. Red, yellow, and gray/green. Cotton, United States, 1966.

Dotted grid for country theme. Yellow, orange, and brown. Cotton, United States, 1966.

Dots and flowers form background in kitchen design in yellow, red, and green. Cotton, United States, 1963.

Dots and flowers form background in kitchen design in pinks and blues. Cotton, United States, 1963.

Dark green and white dots provide grid for country print on pink ground. Cotton, United States, 1954.

Red and white dots provide grid for country print on blue ground. Cotton, United States, 1954.

White dots on red bow on white ground with red dots. Cotton, United States, 1958.

Pink and white polka dot bow on black and pink ground. Cotton, United States, 1958.

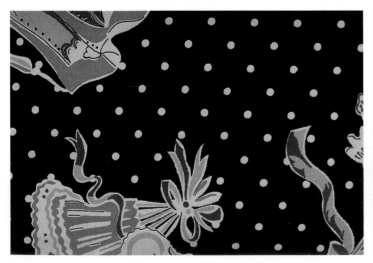

White on black dots with umbrellas, blankets, and bows. Cotton, United States, 1949.

Blue dots with geometric floral motif on bone. Silk, France, 1966.

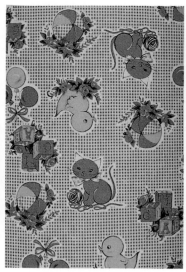
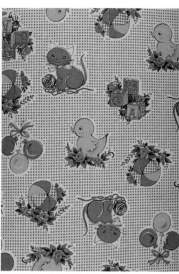
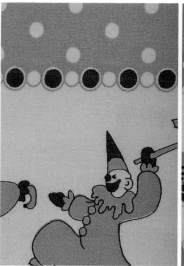
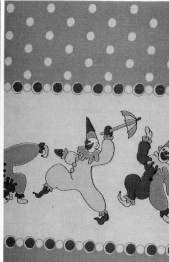

Two directional children's theme on lavender and white dotted ground. Cotton, United States, 1966.

Two directional children's theme on green and white dotted ground. Cotton, United States, 1966.

White polka dots on pink with clown and red and white dot border. Cotton, United States, 1951.

White polka dots on blue with clown and red and white dot border. Cotton, United States, 1951.

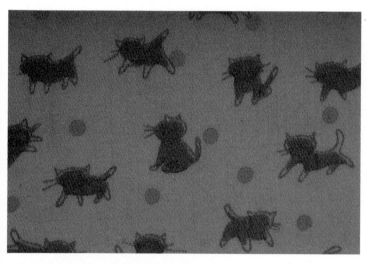
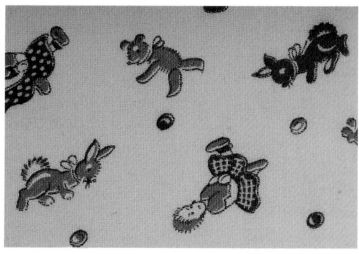

Green dots and pink kittens. Cotton, France, 1963.

Dots with dolls and toys. Cotton twill, France, 1965.

Pink and blue children's motif on white. Cotton twill, France, 1965.

Pink dots and blue birds. Cotton, France, 1963.

Blue on white with children's motif. Cotton, France, 1964.

White on yellow with fruit, kittens, and chicks. Cotton, France, 1964.

Red dots on white ground with colorful children's characters. Cotton, United States, 1963.

Light blue dots on white ground with colorful children's characters. Cotton, United States, 1963.

Color variations on children's print. Cotton, United States, 1963.

Color variations on children's print. Cotton, United States, 1963.

Dots and Buds

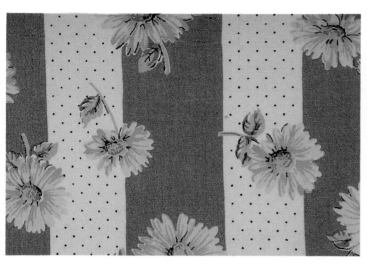

Alternating polka dot and solid stripes with daisies. Cotton, United States, 1959.

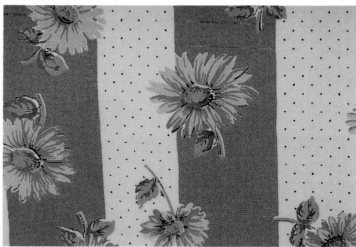

Alternating polka dot and solid stripes with daisies. Cotton, United States, 1959.

Polka dots on stripes with flowers. Cotton, United States, 1942.

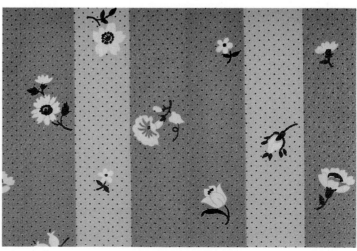

Polka dots on stripes with flowers. Cotton, United States, 1942.

Blue dots and flowers in stripe pattern. Cotton, France, 1965.

Dots are crucial elements in floral design in red on white. Cotton, United States, 1958.

Dots in plaid with flowers. Cotton, United States, 1942.

Dots and X's form grid with flowers. Cotton, United States, 1942.

Gray dots on striped pink floral pattern. Cotton, France, 1965.

Dot and grid pattern with oversized floral design. Cotton, United States, 1951.

Dotted ground with floral motif. Cotton, United States, 1942.

Colored dots in allover floral design. Cotton, United States, 1939.

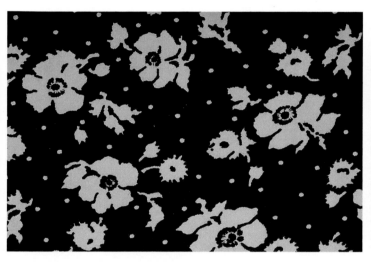

White dots in navy and white floral design. Cotton, United States, 1939.

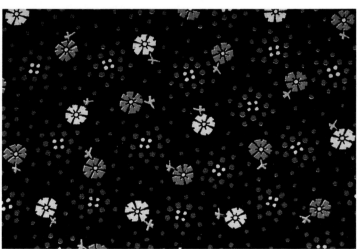

Dot clusters with flowers. Cotton, United States, 1954.

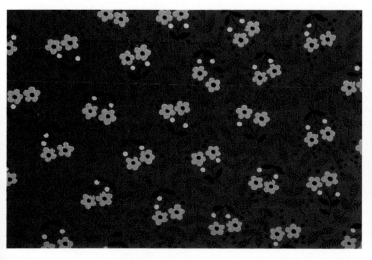

Black dots form foliage in floral motif. Cotton, United States, 1958.

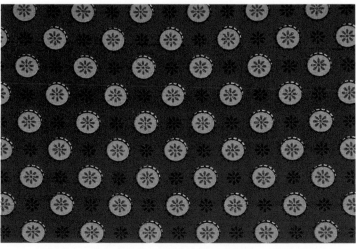

Yellow dots on red with floral motif. Cotton, United States, 1958.

White dotted, black ground with red and yellow daisies on white ground. Cotton, United States, 1954.

Scattered dots with flowers. Cotton novelty weave, France, 1964.

Dotted leaves in red, green, and blue floral motif. Cotton, United States, 1938.

Dots in circle and flower design. Cotton, United States, 1938.

Leaves with dotted outlines on black ground. Cotton, United States, 1938.

Flowers with dotted outlines on light blue ground. Cotton, United States, 1938.

Floral bunches on dotted blue and white ground. Cotton, United States, 1966.

Floral bunches on dotted yellow and white ground. Cotton, United States, 1966.

Floral bunches on dotted pink and white ground. Cotton, United States, 1966.

Floral bunches on dotted lavender and white ground. Cotton, United States, 1966.

Dotted lines intertwined in floral pattern. Cotton, United States, 1953.

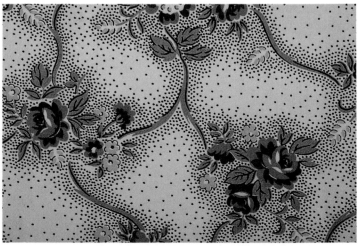

Black dots in allover floral design. Cotton, United States, 1953.

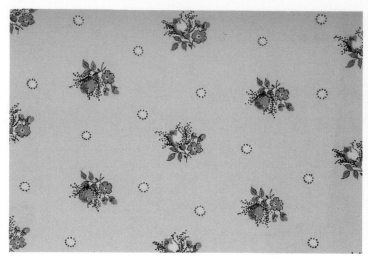

Dotted dots with flowers. Cotton, United States, 1954.

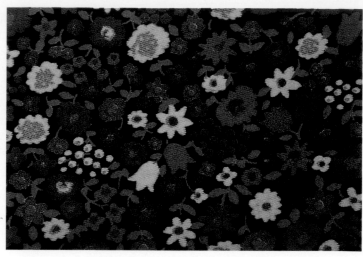

Bright dot and flower pattern. Cotton/polyester, France, 1965.

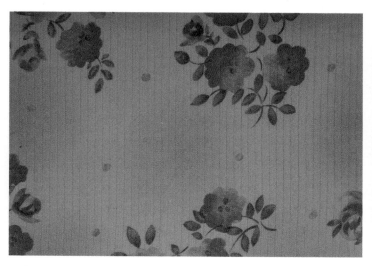

Blue floral design on white. Polyester/cotton, France, 1965.

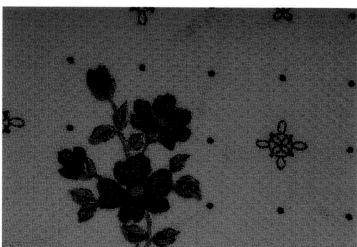

Black dots with red flowers on white. Cotton novelty weave, France, 1965.

Lace and floral design on dotted beige ground. Cotton, United States, 1970.

Lace and floral design on dotted pink ground. Cotton, United States, 1970.

Dots on dots on dots with floral motif in browns, orange, yellow, and green. Cotton, United States, 1950.

Dots on dots on dots with floral motif in grays, browns, yellow, and pink. Cotton, United States, 1950.

Dots on dots on dots with floral motif in blues, pink, and green. Cotton, United States, 1950.

Dots on dots on dots with floral motif in pinks, blue, and green. Cotton, United States, 1950.

Dots fill white space in large foliage design in blue, brown, and gold. Cotton, United States, 1951.

Dots fill white space in large foliage design in pink, black, and gray. Cotton, United States, 1951.

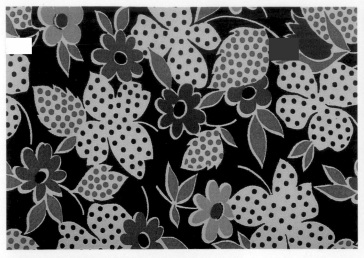

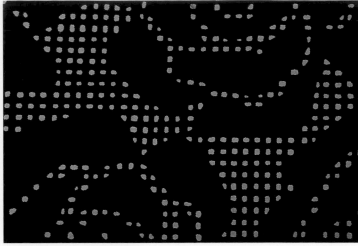

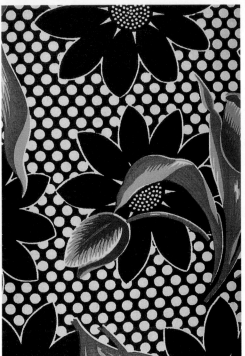

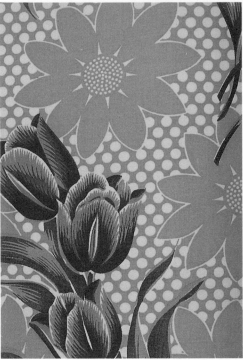

Top left: Dotted leaves and flowers on black ground. Cotton, United States, 1938.

Top right: White dots create lacy rose pattern. Cotton/polyester, France, 1963.

Center left: Dotted black and white ground with floral motif. Cotton, United States, 1952.

Center: Dotted gold and white ground with floral motif. Cotton, United States, 1952.

Bottom left: Dots on blue flowers on a white ground. Cotton, United States, 1952.

Bottom center: Dots on brown and gold flowers on a white ground. Cotton, United States, 1952.

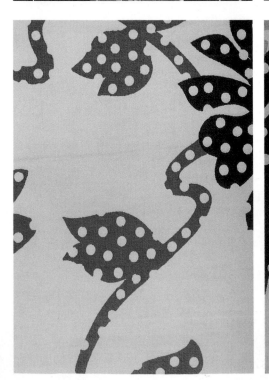

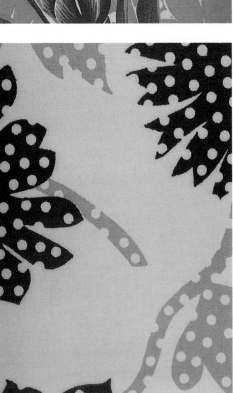
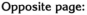

Opposite page:
Top left: Dotted leaves and flowers on red ground. Cotton, United States, 1938.

Top right: Dotted leaves and flowers on blue ground. Cotton, United States, 1938.

Bottom left: Dotted leaves and flowers on brown ground. Cotton, United States, 1938.

Bottom right: Dotted leaves and flowers on navy ground. Cotton, United States, 1938.

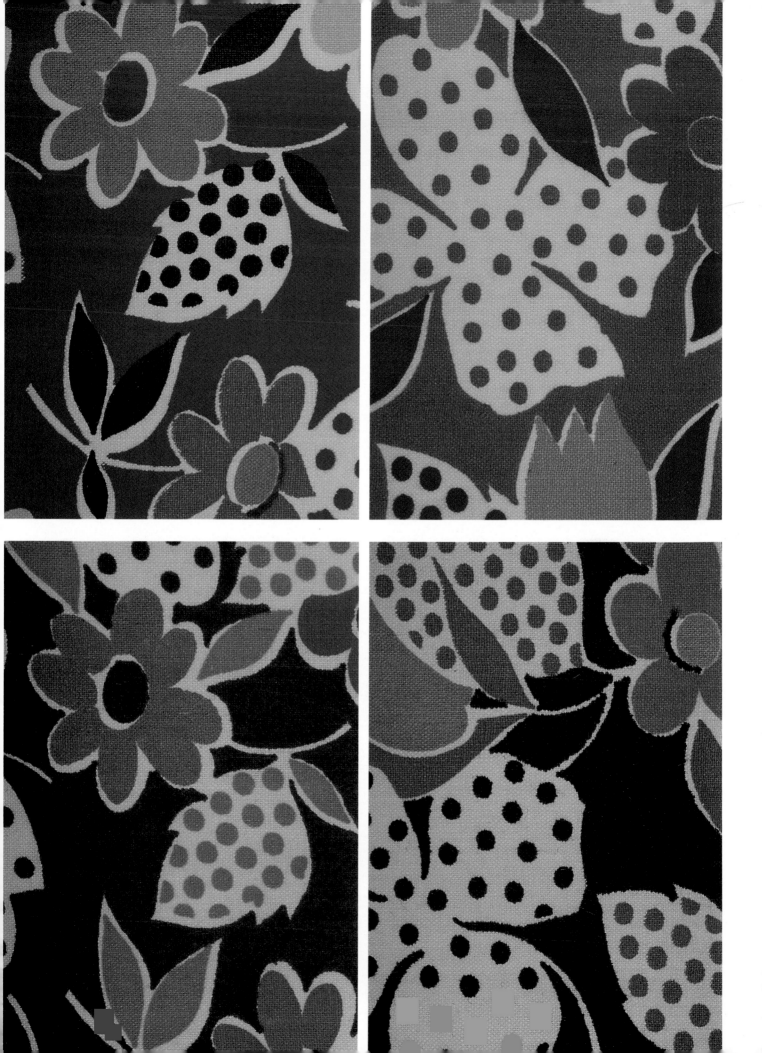

Yellow dot and snowflake design. Cotton, United States, 1953.

Flowers and dots on red. Cotton, United States, 1938.

White dots with assorted floral, fruit, and butterfly motifs surrounded by blue dots on red ground. Cotton, United States, 1958.

White dots on blue ground connected by brown stars. Cotton, United States, 1949.

Big and little pink dots on light pink ground with black. Cotton, United States, 1958.

Dotted floral grid on blue. Cotton/polyester, France, 1963.

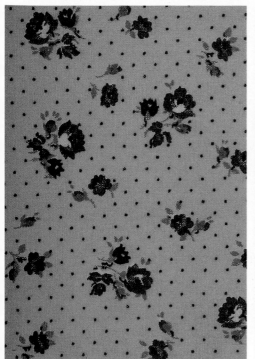

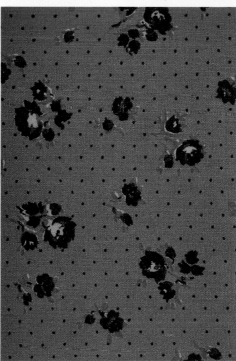

Top left: Pink on white. Cotton bird's eye weave, France, 1965.

Top right: Dotted red flowers on white ground. Cotton, United States, 1970.

Center left: Dotted ground with two-directional floral prints. Yellow. Cotton, United States, 1954.

Center: Dotted ground with two-directional floral prints. Turquoise. Cotton, United States, 1954.

Bottom left: Dotted ground with two-directional floral prints. Blue dots with red flowers. Cotton, United States, 1954.

Bottom center: Dotted ground with two-directional floral prints. Red dots with blue flowers. Cotton, United States, 1954.

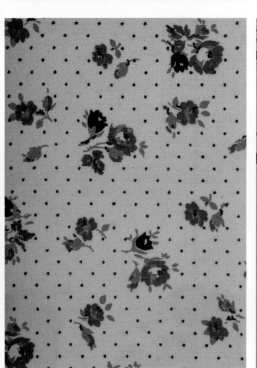

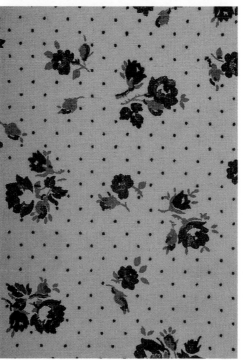

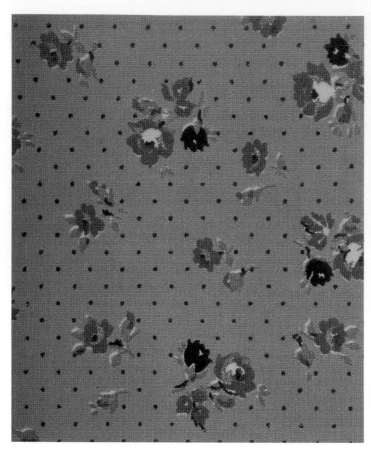

Dotted ground with two-directional floral prints. Pink. Cotton, United States, 1954.

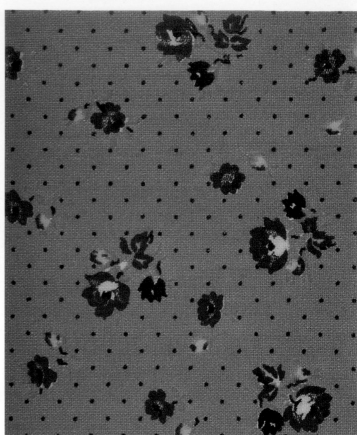

Dotted ground with two-directional floral prints. Light blue. Cotton, United States, 1954.

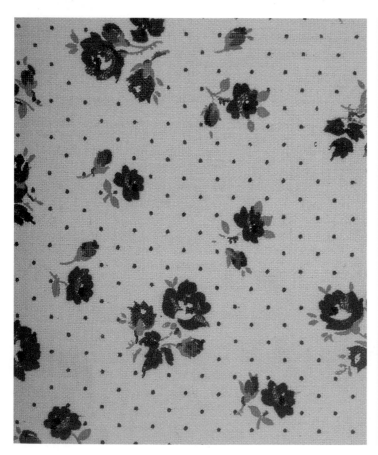

Dotted ground with two-directional floral prints. White dots on red floral design. Cotton, United States, 1954.

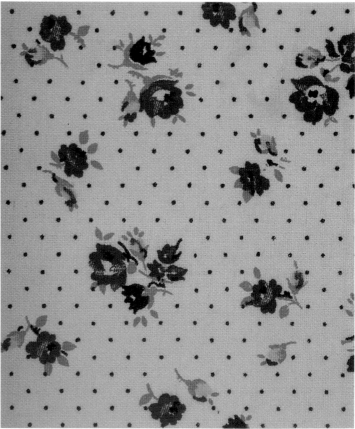

Dotted ground with two-directional floral prints. Blue dots with red flowers. Cotton, United States, 1954.

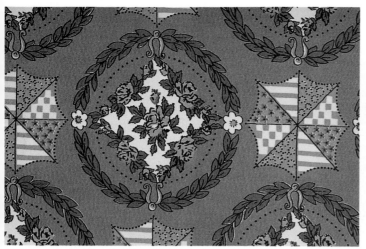

Dots provide outlines in novelty pattern. Cotton,
United States, 1958.

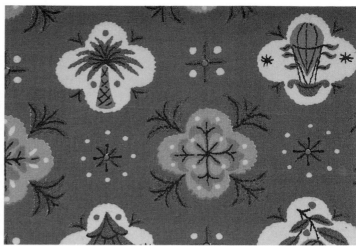

Dots add highlights to novelty pattern. Cotton,
United States, 1958.

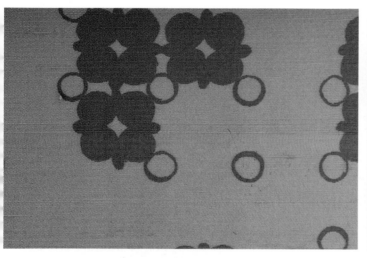

Orange on white. Rayon/linen, France, 1963.

Dots and flowers on gray. Rayon, France, 1963.

Dot berries with floral design on cranberry red. Slubbed rayon,
France, 1963.

Black and pink on white. Cotton novelty weave, France, 1964.

Dots alternate with flowers on gray ground. Silk, France, 1965.

Lavender and blue on yellow. Cotton, France, 1966.

Blue and yellow dots with foliage. Cotton/polyester, France, 1963.

Floral pattern with yellow dots on black. Polyester, France, 1965.

Pink and gray on white. Cotton/rayon, France, 1963.

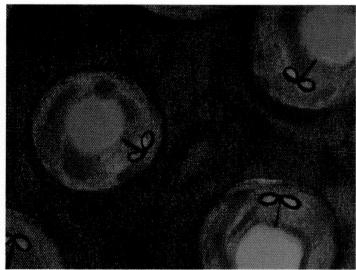

Green with yellow and white on brown. Cotton/polyester, France, 1963.

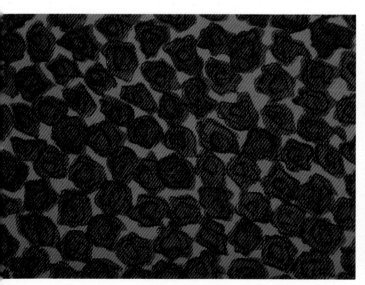

Green and brown on white. Polyester twill, France, 1964.

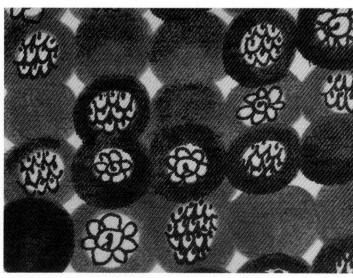

Two brown tones of flowered dots on white. Cotton, France, 1965.

Decorated Dots

Top left: Black on pink with elaborate floral motif. Cotton, United States, 1958.
Center left: Dots with paisley centers. Yellow, green, orange, and brown. Polyester twill, France, 1964.
Bottom left: Large ornamented dots. Slubbed rayon/linen, France, 1964.

Top right: Red, white, and black bandanna pattern. Cotton, United States, 1959.
Center right: Brown and black on white. Polyester/cotton, France, 1965.
Bottom right: Circles and squares on imitation weave plaid. Polyester, France, 1964.

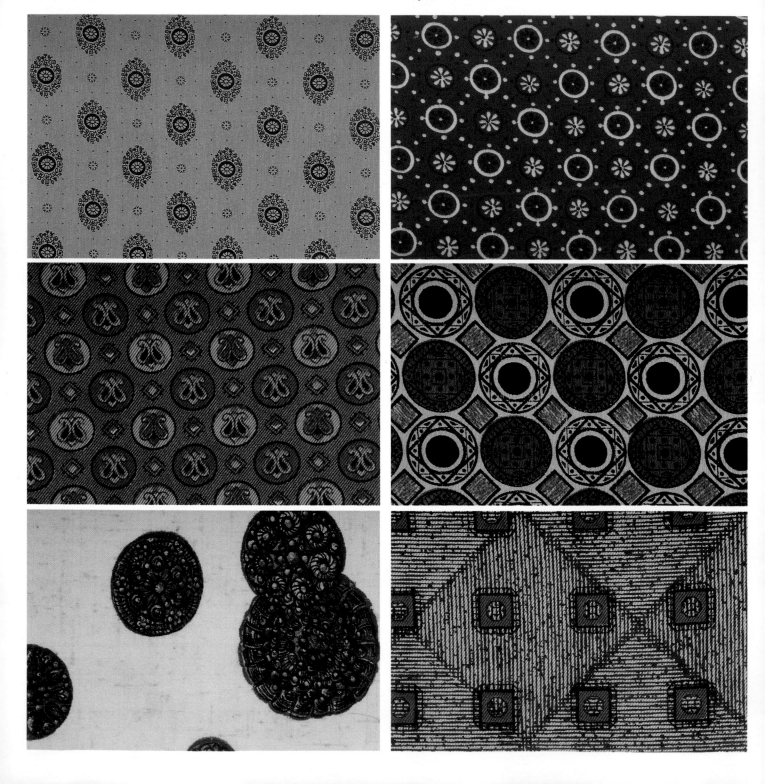

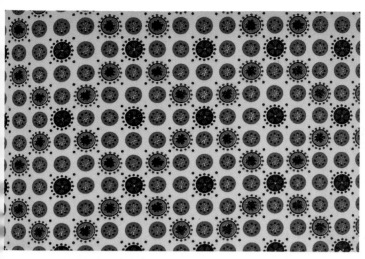

Dots on dots with floral check pattern. Cotton, United States, 1938.

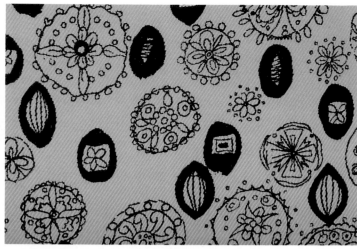

Black and white. Rayon twill, France, 1965.

Dotted paisley. Yellow, green, and brown. Cotton/polyester, France, 1965.

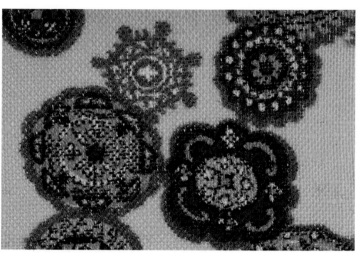

Ornamented dots on yellow ground. Cotton/rayon burlap, France, 1964.

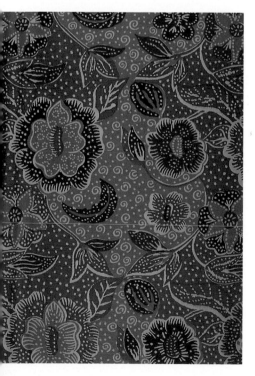

Dots are important element in elaborate floral design on green ground. Cotton, United States, 1959.

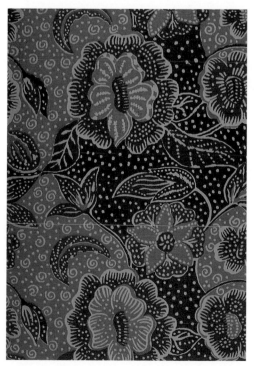

Dots are important element in elaborate floral design on blue ground. Cotton, United States, 1959.

Dots Squared

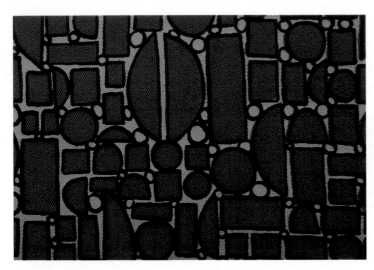

Blue and white. Nylon, France, 1962.

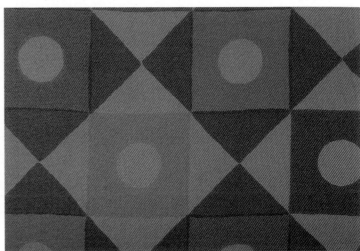

White, yellow, blue, and green. Nylon, France, 1966.

White on black. Rayon twill, France, 1963.

Half circle pattern. wool, France, 1967.

Positive and negative dots in vertical stripe pattern. Silk, United States, 1930s.

Blue and bone egg-like pattern. Silk, United States, 1930s.

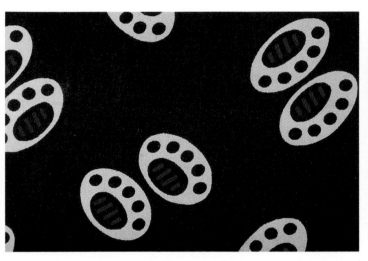

Dots form red, beige, and blue stylized "paw prints." Silk, United States, 1930s.

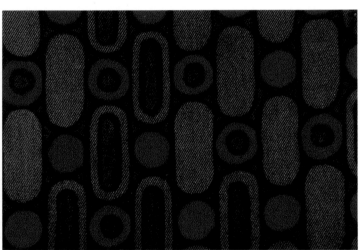

Red and gray on brown. Polyester, France, 1965.

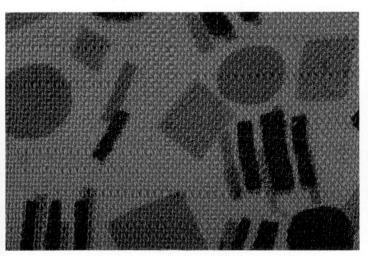

Purple, blue, and green on bone. Viscose, France, 1966.

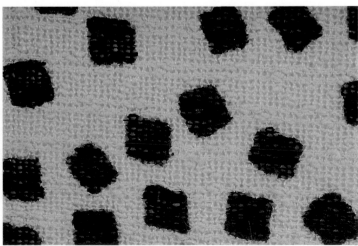

Navy on white. Open weave cotton, France, 1965.

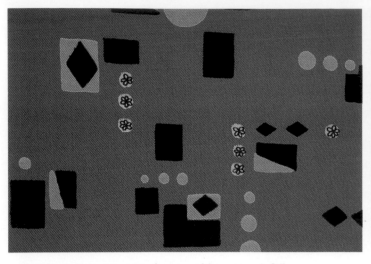

Dots and other geometric forms on blue ground. Silk, France, 1965.

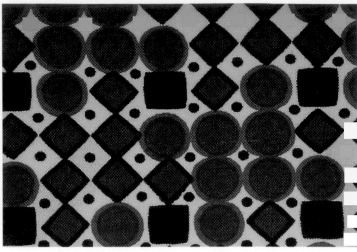

Black and brown on white. Polished cotton, France, 1963.

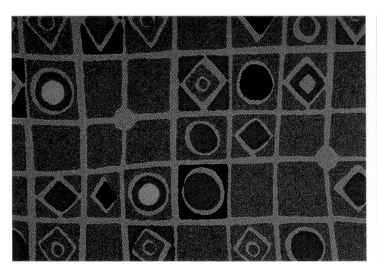

Pink, black, and white on gray. Silk, France, 1966.

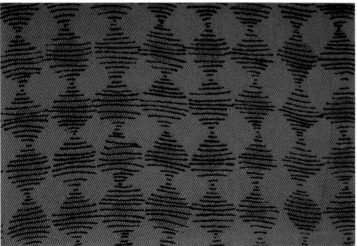

Yellow dots with black hatching on turquoise. Rayon/polyester, France, 1963.

Vertical stripe pattern. Acetate, France, 1963.

Olive, red, and purple on parchment. Cotton, France, 1965.

Psychedelic Dots

Top left: Bright colors with dots in various sizes. Acetate, France, 1965.

Top right: Dots and flowers compete for attention in bright colors. Cotton/acetate, France, 1964.

Bottom left: Pastel colors on green ground. Cotton/acetate, France, 1965.

Bottom right: Blue and lavender on yellow. Polyester, France, 1966.

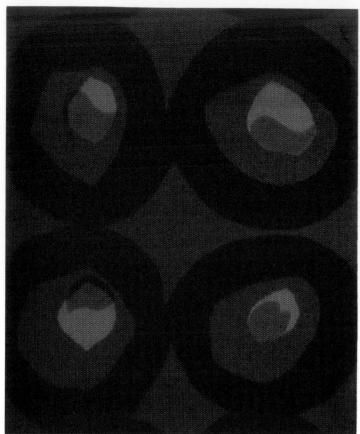

Gray, pink, and white. Silk, France, 1963.

Purple, green, pink, yellow, and orange on black. Rayon, France, 1966.

Pinks on blue ground. Polyester twill, France, 1963.

Yellow and pink flowers on dotted novelty weave. Cotton, France, 1963.

Dots and flowers on black. Cotton/polyester, France, 1963.

Pink, baby blue, and light green dots form loose harlequin pattern on green. Silk, France, 1965.

Pastel floral design. Cotton rayon, France, 1963.

Pink and blue on black. Polyester twill, France, 1963.

Pink, white, and olive. Rayon, France, 1966.

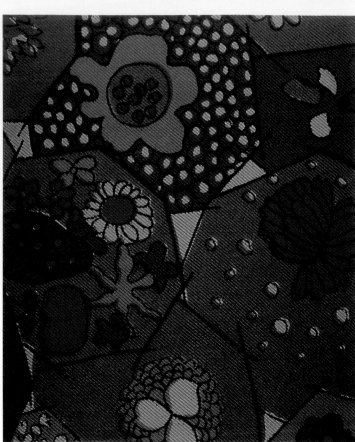

Dots and flowers in mod design. Rayon, France, 1963.

Pink, orange, and lavender on neutral green and blue. Rayon/polyester, France, 1966.

White dots on decorative pink and blue design. Rayon, France, 1962.

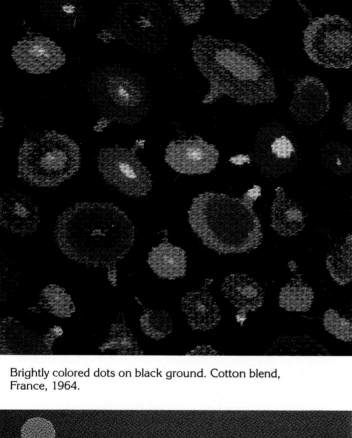

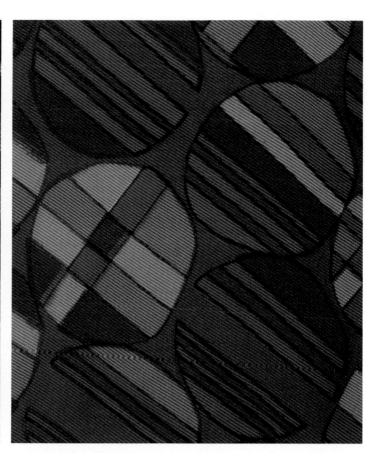

Brightly colored dots on black ground. Cotton blend, France, 1964.

Oversized dots decorated with bright colors. Rayon twill, France, 1959.

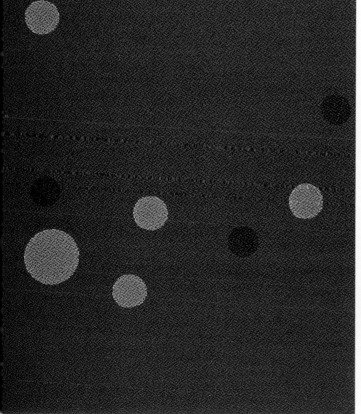

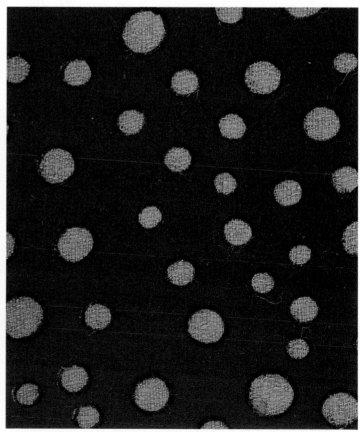

Bright green and navy dots get erratic placement on hot pink ground. France, 1959.

Mod color scheme for black-outlined dots. Cotton/rayon, France, 1962.

Chapter Nine

Abstract Dots

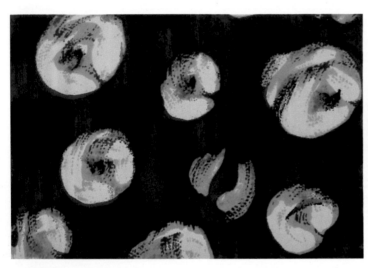

Abstract white and green and black dots on mottled green/blue ground. Silk, France, 1962.

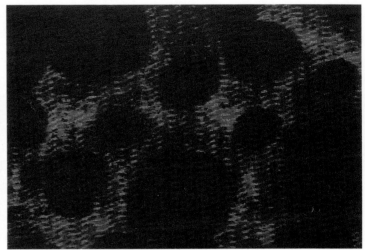

Magenta dots on orange ground. Polyester blend, France, 1963.

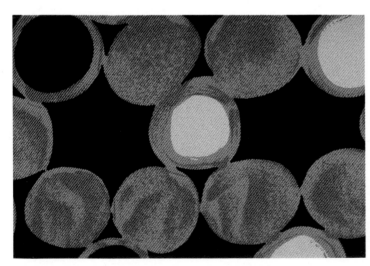

Green and white on black. Polyester, France, 1965.

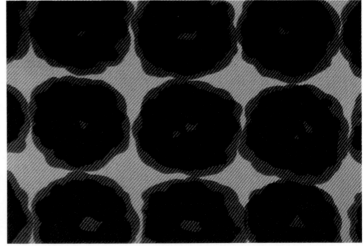

Blue and green on white. Polyester twill, France, 1965.

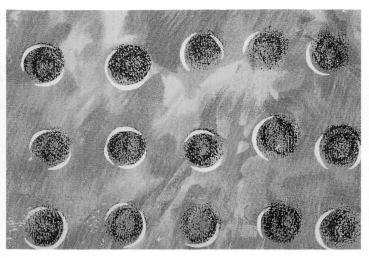

Pointellated black dots on multicolored ground. Cotton, France, 1961.

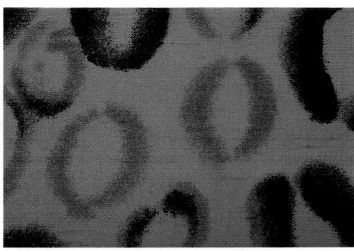

Gold and brown on white. Linen/rayon, France, 1963.

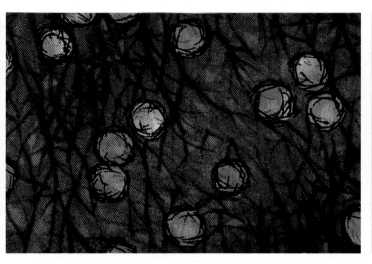

Orange dots get unusual treatment on gray ground. Silk, France, 1962.

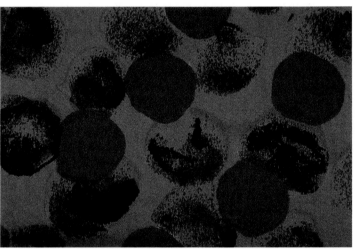

Brown and gray on gold. Silk, France, 1962.

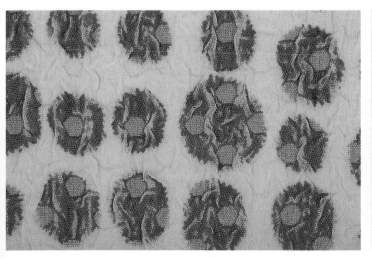

Orange dots on white ground. Cotton/polyester crepe, France, 1965.

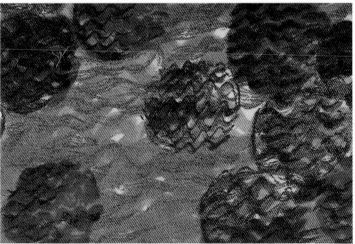

Horizontal waves run through mottled ground and blue and brown dots. Nylon, France, 1962.

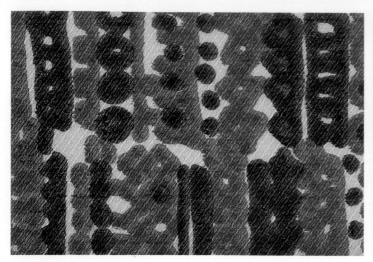

Dark dots in vertical blue on white design. Nylon blend, France, 1965.

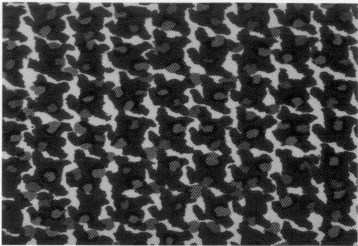

Green dots with outlining on abstract hound's-tooth orange and white print. Silk, France, 1965.

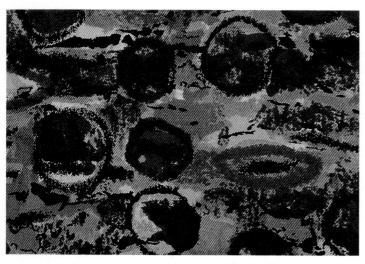

Abstract purple dots on green, yellow, and brown. Silk, France, 1962.

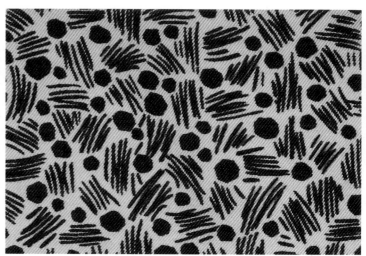

Blue on white. Polyester/rayon, France, 1964.

Blue on white. Cotton novelty weave, France, 1964.

White dots on black and gray. Polyester/cotton, France, 1965.

Brown on white. Quilted cotton, France, 1965.

Light blue dots merge behind "snowballs" of white and gray. Silk blend, France, 1965.

Gray, lavender, brown, and white on black. Silk. France, 1963.

Gray and white on black. Silk twill, France, 1967.

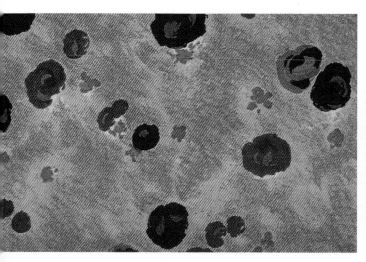

Purples in abstract design. Nylon, France, 1965.

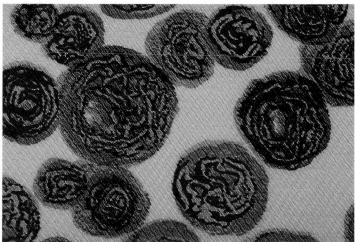

Pink and brown on white. Acetate, France, 1964.

Abstract gray, brown, and pink. Rayon, France, 1963.

Purple and orange dots in large dots. Nylon, France, 1964.

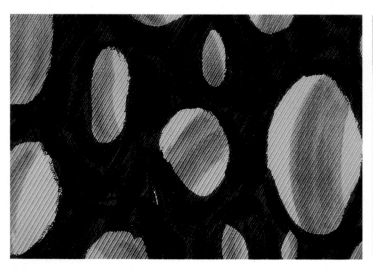

White and beige on blue and black. Polyester/rayon novelty weave, France, 1964.

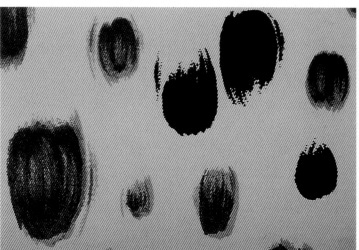

Brushed dots on white ground. Rayon, France, 1964.

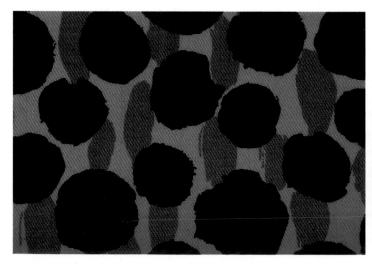

Brown dots and mustard stripes on white ground. Rayon twill, France, 1964.

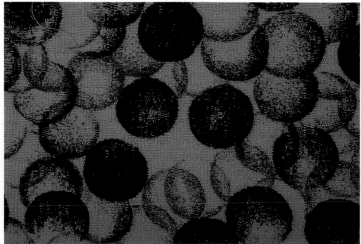

Brown on white creates bubble-like effect. Cotton novelty weave, France, 1964.

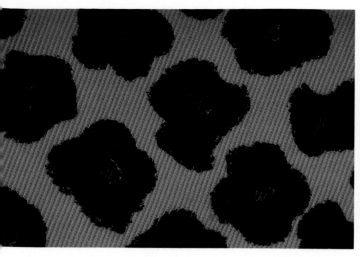

Turquoise on blue and white. Cotton twill, France, 1963.

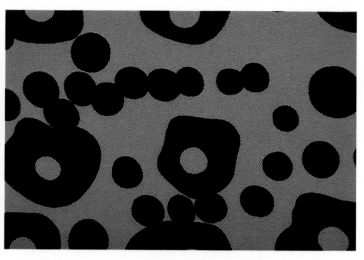

Browns on white. Cotton/polyester, France, 1966.

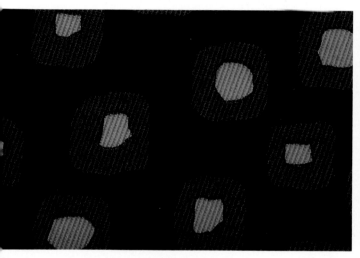

White on browns. Cotton twill, France, 1963.

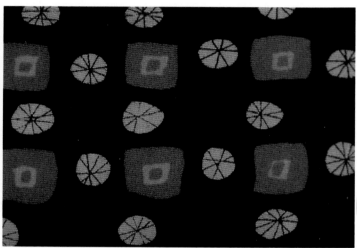

Squares and dots on black ground. Polyester, France, 1965.

Black and white, abstract. Cotton/polyester, France, 1964.

Black dots on gray, orange, and white. Silk, France, 1962.

Brown and gray on white. Polyester/cotton, France, 1965.

Brown and black on white. Polyester, France, 1966.

Gray dots on velour/net. Cotton/nylon, France, 1965.

Orange and white on brown. Rayon, France, 1966.

Brown and blue vertical stripes. Rayon, France, 1962.

Blues and yellow on white. Rayon, France, 1963.

Pointellated black dots on multi-colored ground. Cotton/polyester, France, 1963.

Blue on blue with red, orange, and yellow highlights. Nylon, France, 1964.

Green, blue, and gold. Silk, France, 1964.

Blue and purple on beige. Polyester, France, 1963.

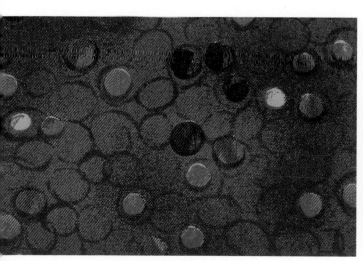

Gray on pink. Polyester, France, 1965.

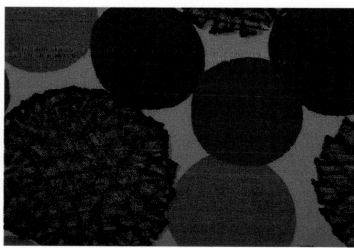

Oranges and browns on white. Cotton/acetate, France, 1964.

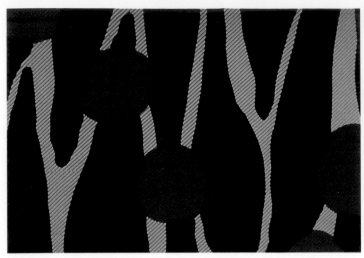

Red on vertical black and white. Rayon twill, France, 1963.

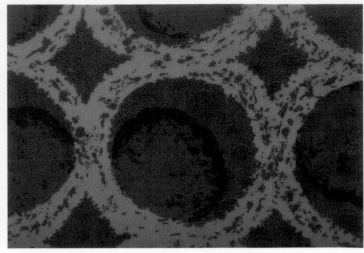

Bright peach and olive green on white. Cotton novelty weave, France, 1963.

Green on green. Cotton novelty weave, France, 1961.

Greens. Cotton, France, 1964.

Abstract with dots and flowers. Silk twill, Italy, 1964.

Grays on white. Nylon, France, 1965.

Blue on white. Cotton crepe novelty weave, France, 1964.

Animal print effect with brown and gray dots on beige, Silk, France, 1965.

Green and red on black. Polyester, France, 1966.

Black dots on vertical stripes on white. Acetate, France, 1964.

Light blue on white. Open weave cotton, France, 1965.

Pink and gray dots on black and blue ground. Silk, France, 1965.

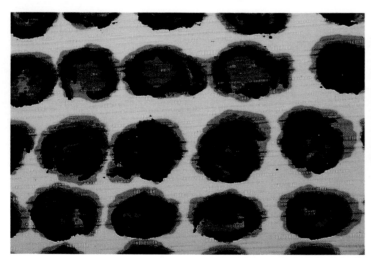

Purple and pink on white. Cotton novelty weave, France, 1965.

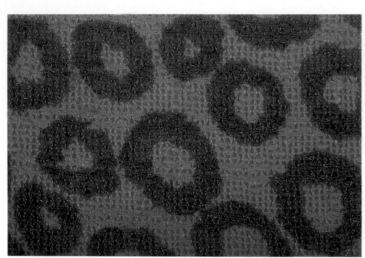

Pastel blue lavender and orange on white. Silk, France, 1962.

Dot Like All the Rest

Orange outlines and blue centers on black. France, 1966.

Turquoise on browns. Cotton, France, 1963.

Red and black dots on white. Cotton novelty weave,
France, 1963.

Brown, black, and mustard on white. Silk, France, 1966.

Greens and gold with black and white. Rayon twill, France, 1963.

Green outline dots with yellow. Polyester, France, 1963.

Bomb-shelter design in black and yellow on white. Acetate, France, 1964.

Brown and bone on black. Rayon, France, 1963.

Chickens with dots and dotted O's. Cotton, United States, 1942.

Dotted dots with flowers. Cotton, United States, 1942.

Elongated dots on gray ground. Cotton, United States, 1958.

Pink, blue, and green. Rayon, France, 1966.

Semi-circles form vertical stripes. Silk, United States, 1930s.

Dotted red and bone dots on navy blue ground. Silk, United States, 1930s.

Red and black and hound's-tooth dots on white ground. Nylon blend, France, 1964.

Black and brown on white. Cotton, France, 1963.

Dotted squares on abstract black and red ground. Rayon/polyester, France, 1964.

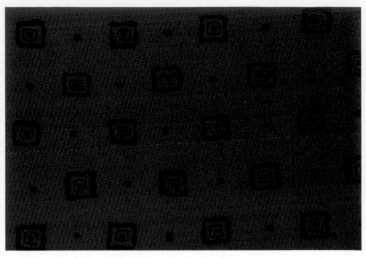

Black on red. Cotton twill, France, 1963.

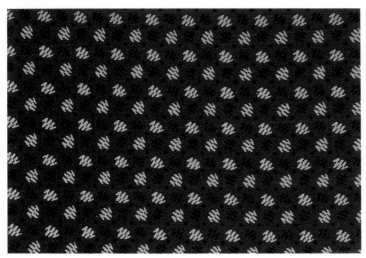

Dots with abstract symbols on red. Cotton, United States, 1958.

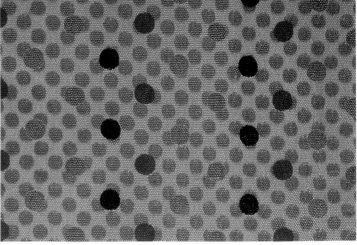

Pink dots on vertical black and white stripe design. Polyester, France, 1965.

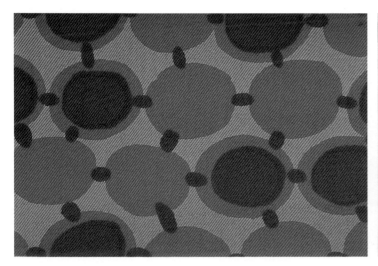

Turquoise and blue dots on taupe ground. Polyester, France, 1963.

A color variation dominated by orange. Silk, United States, 1940s.

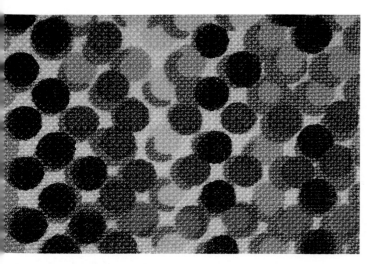

Brightly colored dots with shadows on white ground. Cotton/acetate, France, 1965.

Hot color water spot on white. Silk twill, France, 1962.

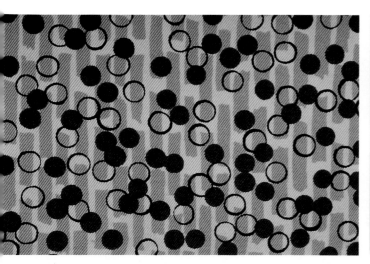

Blue dots and circles on vertical gray and white ground. Polyester, France, 1964.

Blue on white. Polyester/rayon novelty weave, France, 1964.

Brown and blue dots on blue. Polyester/cotton, France, 1964.

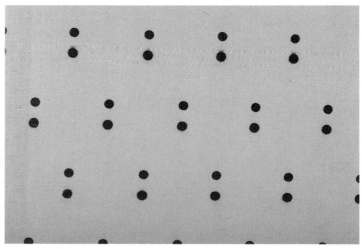

Red and blue dots on white ground. Cotton, United States, 1956.

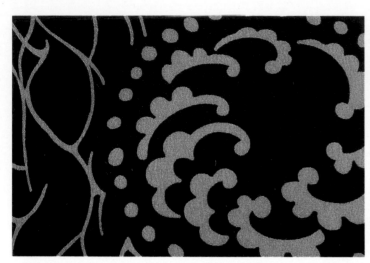

White dots circle cloud-like design. Silk, United States, 1930s.

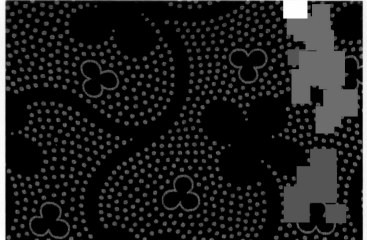

Dotted black ground with clover motif. Polyester blend, United States, 1930s.

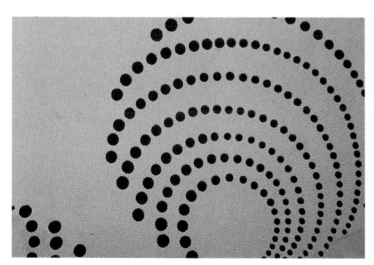

Varying size dots form nautilus-type pattern. Silk, United States, 1930s.

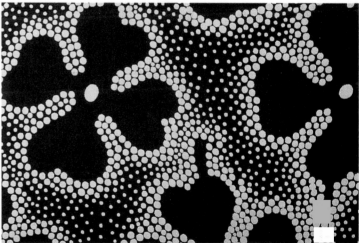

Dots provide outline for clover design. Silk, United States, 1930s.

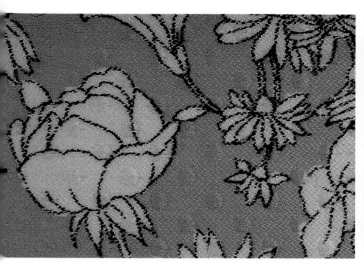

Woven dots with blue floral print on white. Cotton and silk, France, 1963.

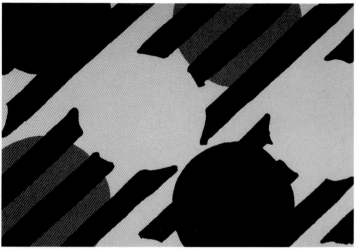

Black and brown on white. Rayon, France, 1966.

Stylized leaf pattern with yellow, orange, and gray. Slubbed rayon, France, 1964.

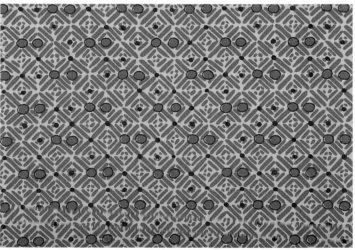

Outlined green dots and blue dots on blue and white plaid. Cotton, United States, 1958.

Yellow and gray on white. Polyester twill, France, 1963.

Black and beige. Silk, United States, 1930s.

Irregular dots on vague plaid of browns and white. Nylon, France, 1964.

Bubble-like effect created by white outlined dots and shadows. Cotton, United States, 1958.

Yellow, blue and green on black. Cotton novelty weave, France, 1964.

Blue, orange, and green. Mohair blend knit, France, 1966.

Checkered dots on blue ground. Silk, France, 1964.

Black with orange and green doughnuts. Open weave cotton/rayon, France, 1964.

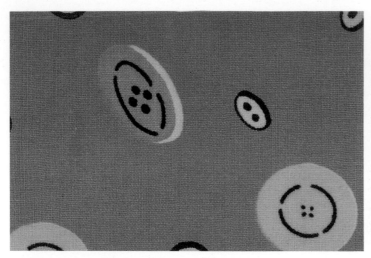

Dots become buttons on pink ground. Cotton,
United States, 1948.

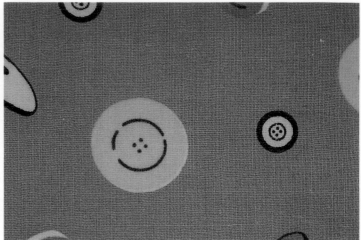

Dots become buttons on gray ground. Cotton,
United States, 1948.

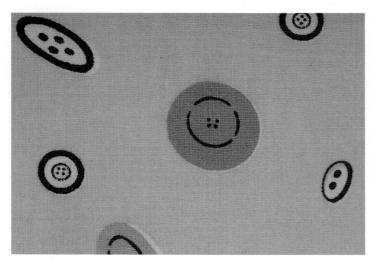

Dots become buttons on yellow ground. Cotton,
United States, 1948.

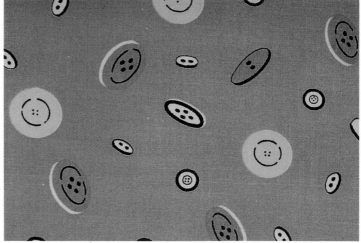

Dots become buttons on blue ground. Cotton,
United States, 1948.

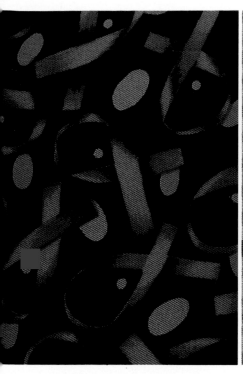

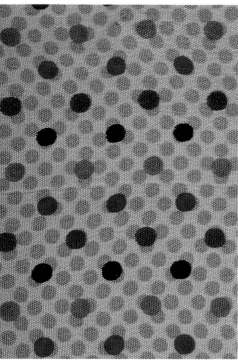

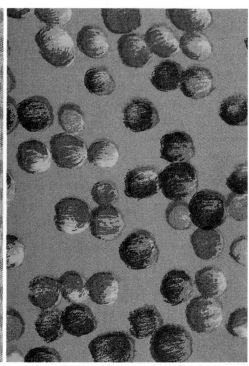

Pink and green with brown ribbons on black. Polyester, France, 1966.

Double dot grid with larger darker colors on top dominated by blues. Silk, United States, 1940s.

Painterly gray and green dots on pink ground. Silk, France, 1964.

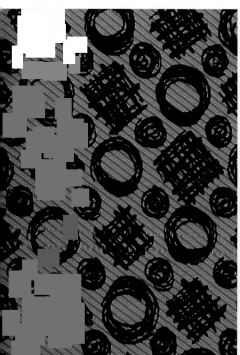

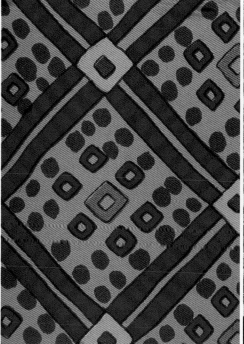

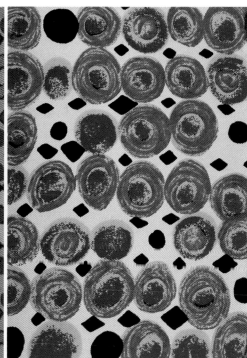

Black and white. Polyester twill, France, 1962.

Brown dots decorate plaid of red, gold, and olive. Silk, France, 1965.

Green, yellow, and orange dots interspersed with black on white ground. Silk, France, 1965.

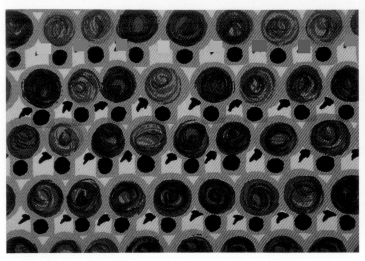

Gold, rose, and black on white. Polyester, France, 1963.

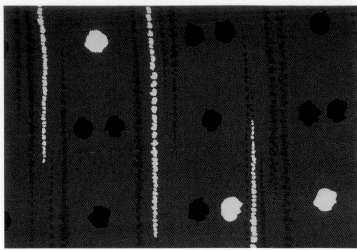

Scattered dots on vertical stripes. Silk, France, 1962.

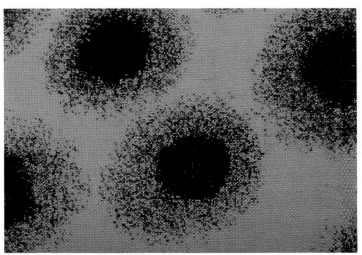

Blue on white. Linen/rayon, France, 1963.

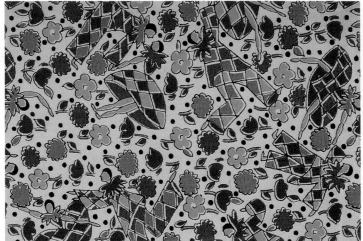

Dotted ground with theatrical floral motif. Cotton, United States, 1938.

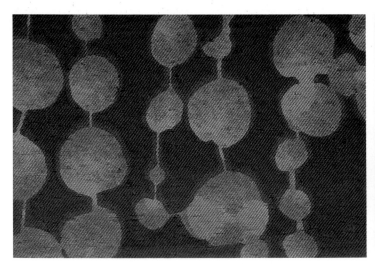

Connected green dots form vertical design on blue ground. Cotton blend, France, 1964.

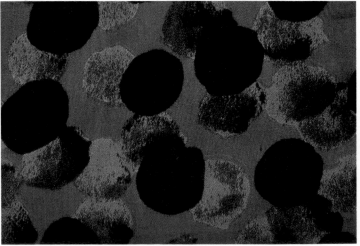

Green and gray on bright green. Rayon, France, 1963.

Dot Again

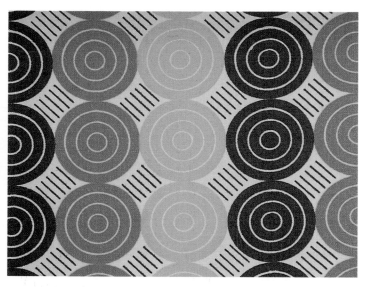

Dots and circles form vertical stripe pattern, blues and salmon. Cotton, United States, 1949.

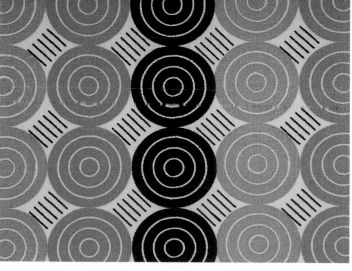

Dots and circles form vertical stripe pattern, greens and pink. Cotton, United States, 1949.

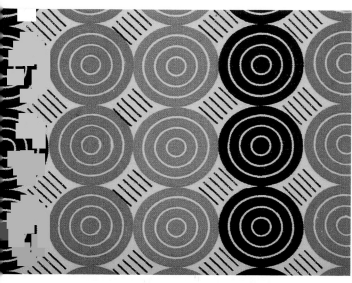

Dots and circles form vertical stripe pattern, yellow, black, and blue. Cotton, United States, 1949.

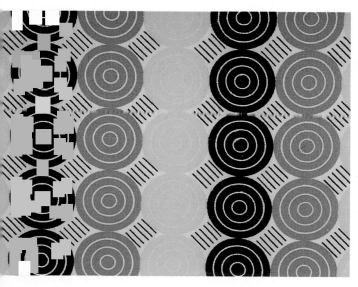

Dots and circles form vertical stripe pattern, black, gray, and salmon. Cotton, United States, 1949.

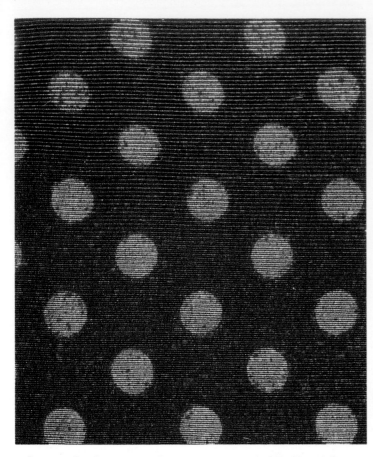

Green polka dots on purple, picotage ground. Silk, United States, 1940s.

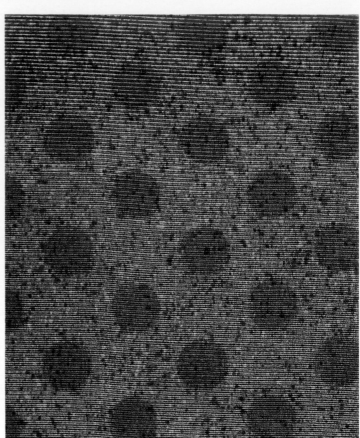

Pink polka dots on green, picotage ground. Silk, United States, 1940s.

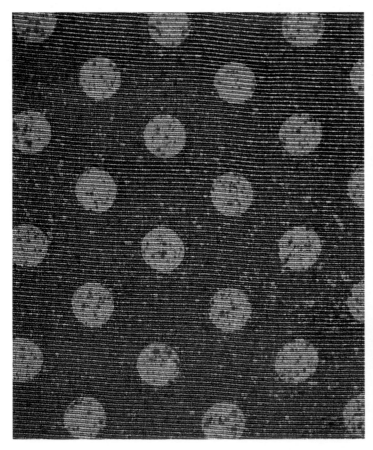

Yellow polka dots on blue, picotage ground. Silk, United States, 1940s.

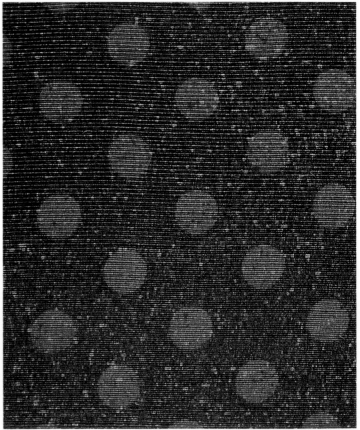

Orange polka dots on blue, picotage ground. Silk, United States, 1940s.

Red and yellow striped dots on blue ground. Cotton, United States, 1949.

Black and yellow striped dots on maroon ground. Cotton, United States, 1949.

Red striped dots on blue ground. Cotton, United States, 1949.

Blue striped dots on pink ground. Cotton, United States, 1949.

Yellow polka dots on pointellated mauve ground. Silk, United States, 1940s.

Gray polka dots on pointellated brown ground. Silk, United States, 1940s.

Dots and flowers on blue ground. Cotton,
United States, 1963.

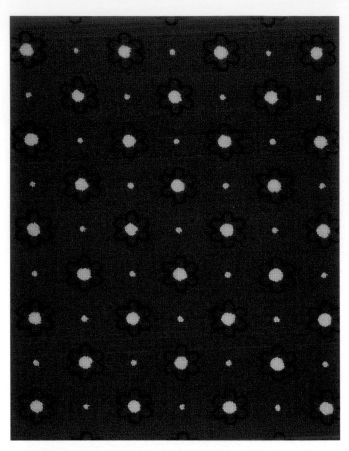

Dots and flowers on red ground. Cotton,
United States, 1963.

Dots and flowers on brown ground. Cotton,
United States, 1963.

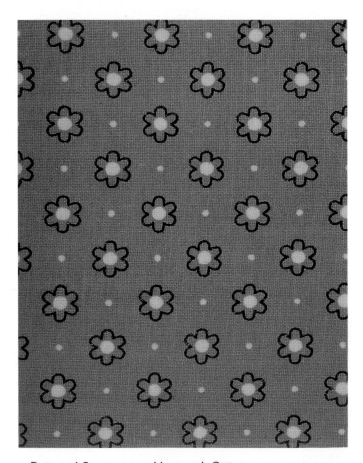

Dots and flowers on gold ground. Cotton,
United States, 1963.

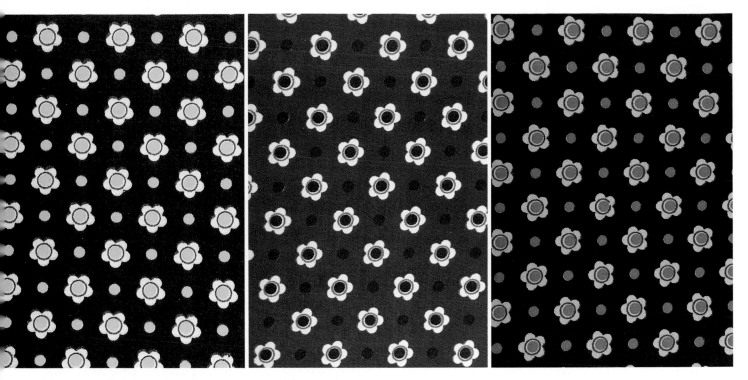

Dots and flowers on black ground. Cotton, United States, 1970.

Dots and flowers on red ground. Cotton, United States, 1970.

Dots and flowers on blue ground. Cotton, United States, 1970.

White on green. Silk twill, United States, 1940s.

White on blue. Silk, United States, 1940s.

White on brown. Silk, United States, 1940s.

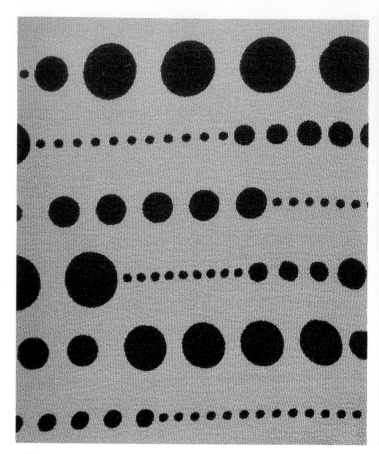

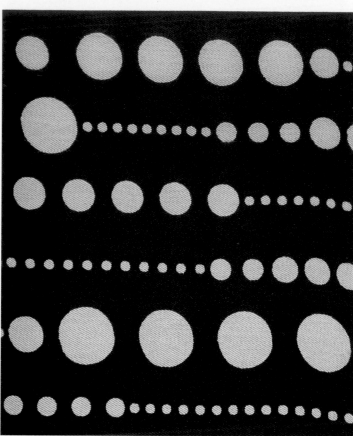

Varying sized dots form vertical striped pattern. Silk, United States, 1930s.

Varying sized dots form vertical striped pattern. Silk, United States, 1930s.

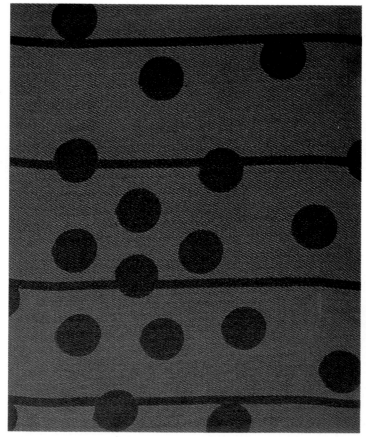

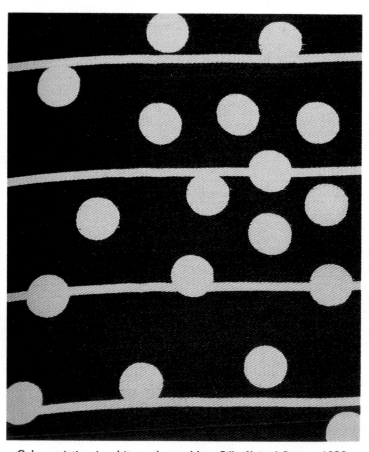

Random dots and stripes in blue on beige ground. Silk, United States, 1930s.

Color variation in white and navy blue. Silk, United States, 1930s.

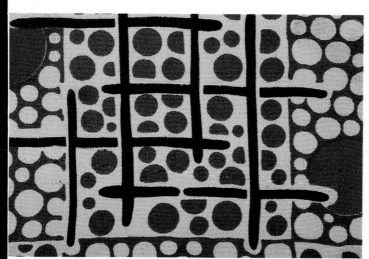

Blue, grape, and white. Silk, United States, 1930s.

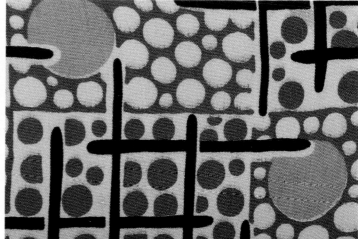

Mint green, brown, and blue. Silk, United States, 1930s.

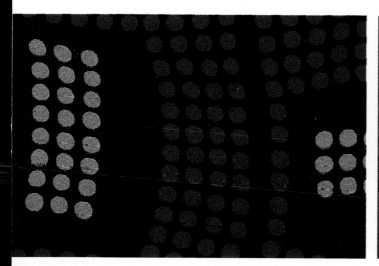

Red and orange dots on navy blue ground. Silk,
United States, 1930s.

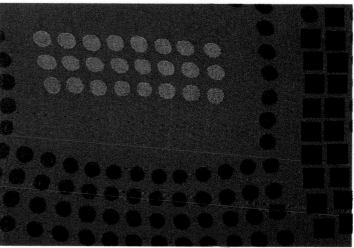

Turquoise and black on red ground. Silk, United States, 1930s.

Mint green and beige. silk, United States, 1930s.

Orange abstract. Silk, United States, 1930s.

Brown and bone white. Silk, United States, 1930s.

Black and sand. Silk, United States, 1930s.

Varied size dots in wavy striped pattern. Silk,
United States, 1930s.

Varied size dots in wavy striped pattern. Silk,
United States, 1930s.

Varied size dots in wavy striped pattern. Silk,
United States, 1930s.

Varied size dots in wavy striped pattern. Silk,
United States, 1930s.

Red, yellow, and black "exaggerated weave" design. Silk, United States, 1930s.

Color variation: red, yellow, and blue. Silk, United States, 1930s.

Color variation: red, brown, and beige. Silk, United States, 1930s.

Pink on white. Cotton, United States, 1959.

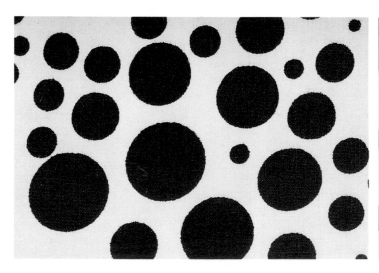

Blue on white. Cotton, United States, 1959.

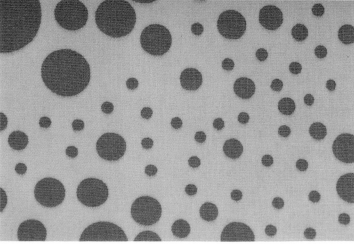

Green on white. Cotton, United States, 1959.

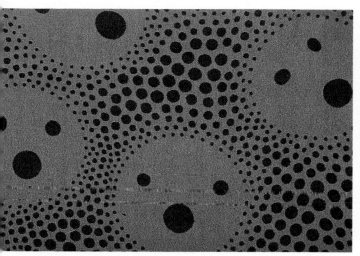

Varying sizes of red dots form circles and background. Silk, United States, 1930s.

Varying sizes of green dots form circles and background. Silk, United States, 1930s.

Black and white. Silk, United States, 1930s.

Blue and white. Silk, United States, 1930s.

Dotted patches are part of faux quilt. Green, yellow, and white. Cotton, United States, 1968.

Dotted patches are part of faux quilt. Red, yellow, and white. Cotton, United States, 1968.

White dots form ribbon and bow pattern on red ground. Silk, United States, 1930s.

Color variation in shades of blue. Silk, United States, 1930s.

Black and green floral plaid design. Cotton, United States, 1970.

Black and red floral plaid design. Cotton, United States, 1970.

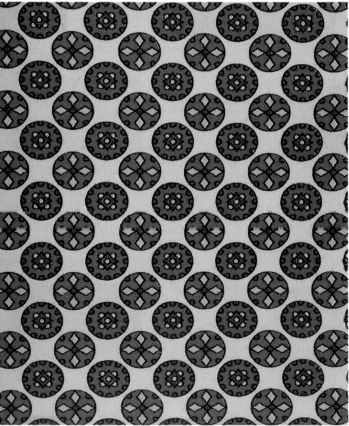

Red dots on blue dots. Cotton, United States, 1938.

Brown dots on green dots. Cotton, United States, 1938.

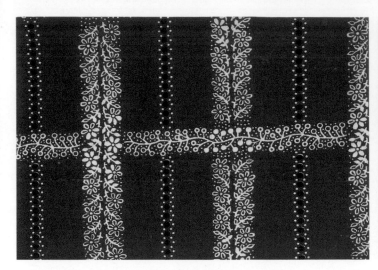

Rows of dots add interest to floral pattern. Cotton,
United States, 1954.

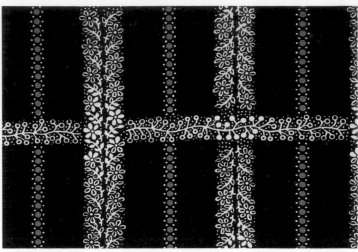

Rows of dots add interest to floral pattern. Cotton,
United States, 1954.

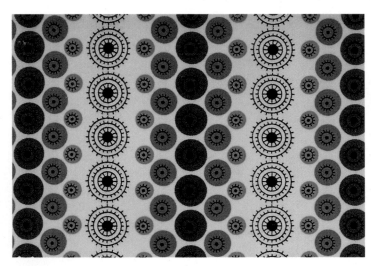

Decorated dots and circles form vertical stripe pattern. Cotton,
United States, 1959.

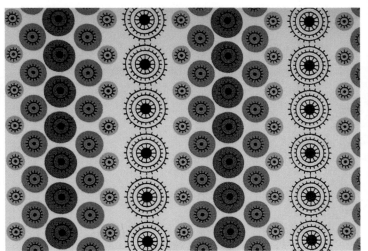

Decorated dots and circles form vertical stripe pattern. Cotton,
United States, 1959.

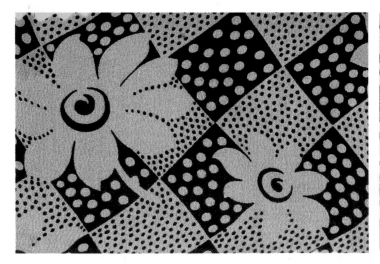

Dots in check pattern in floral motif, blue on sand. Silk, United
States, 1930s.

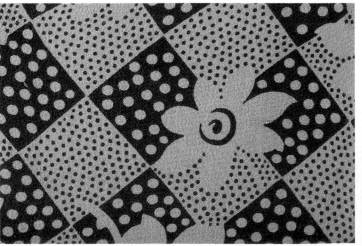

Dots in check pattern in floral motif, brown on beige. Silk, United
States, 1930s.